REAL FUN

POLAROIDS FROM
THE INDEPENDENT
MUSIC LANDSCAPE

ASHOD SIMONIAN

ILLUSTRATIONS BY FRANK SANTORO
EDITED BY SASHA HIRSCHFELD
CREATIVE DIRECTION AND DESIGN BY CIRCLE & SQUARE

PICTUREBOX INC., BROOKLYN

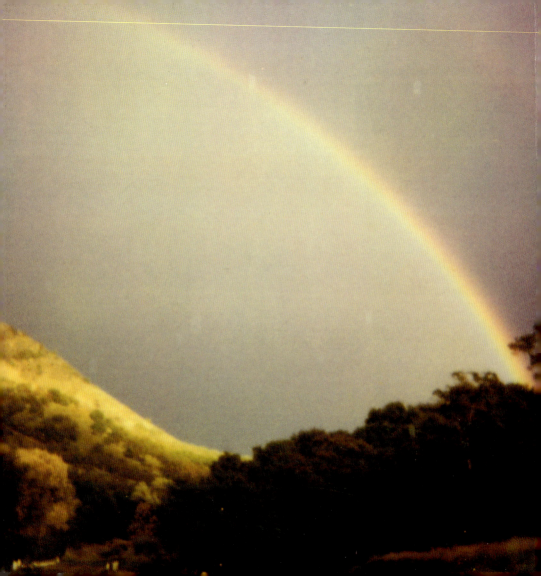

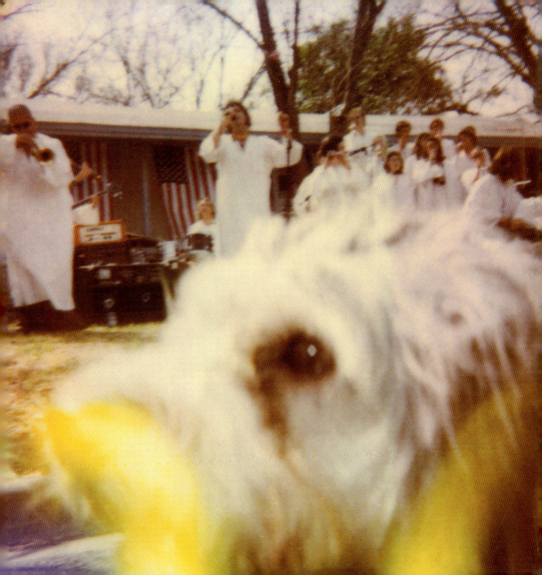

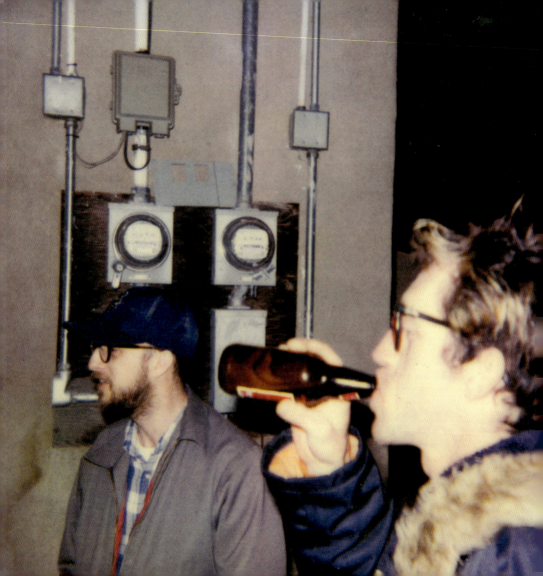

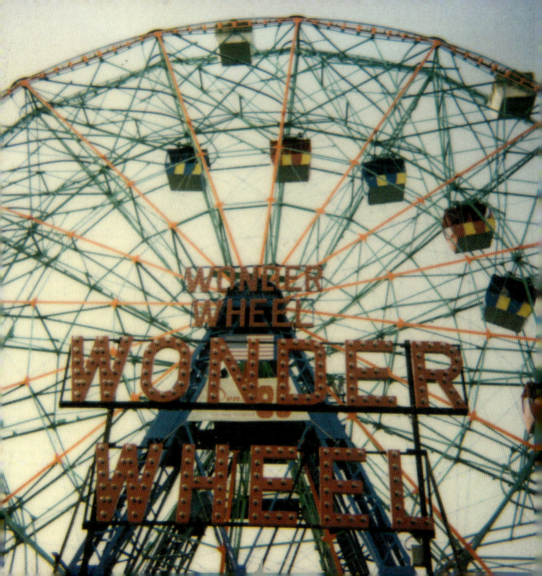

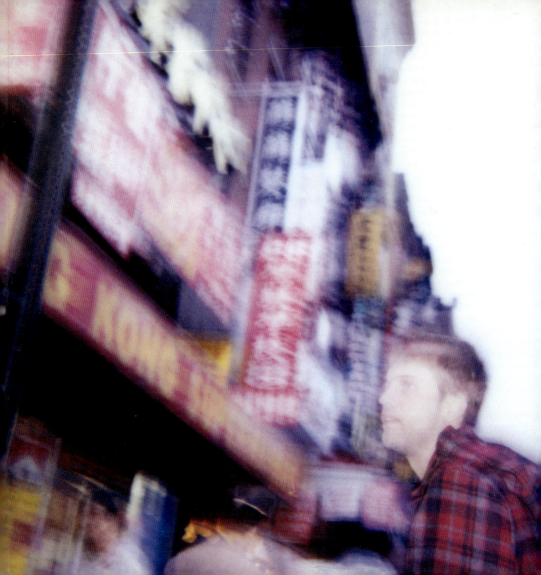

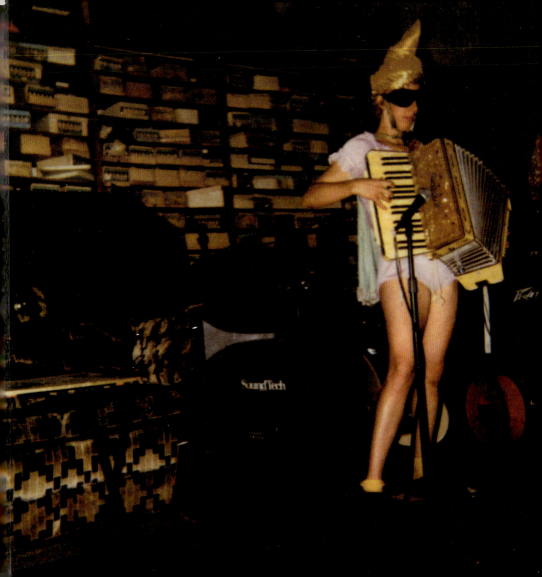

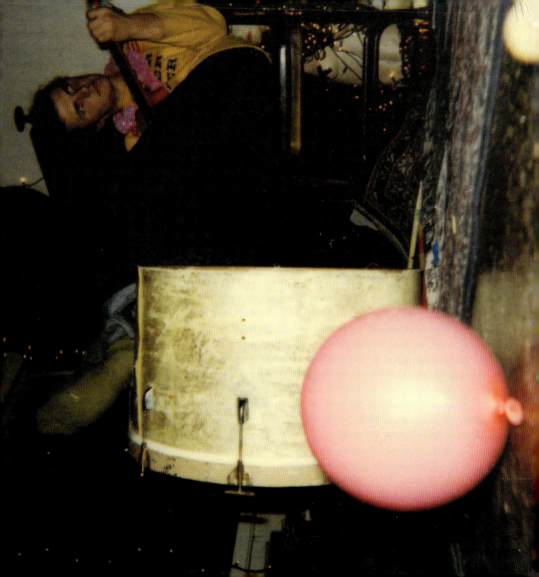

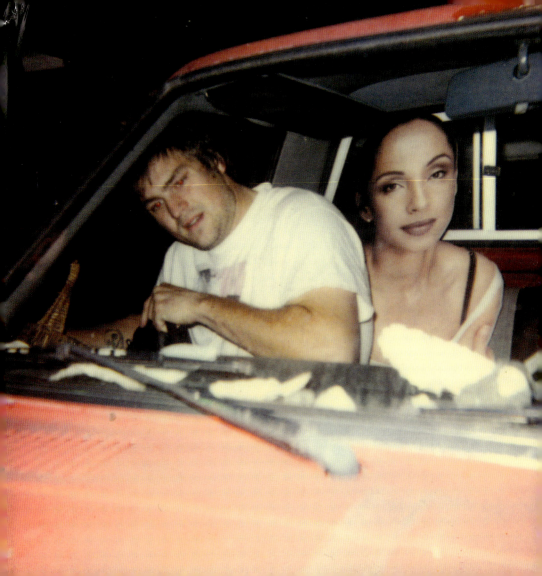

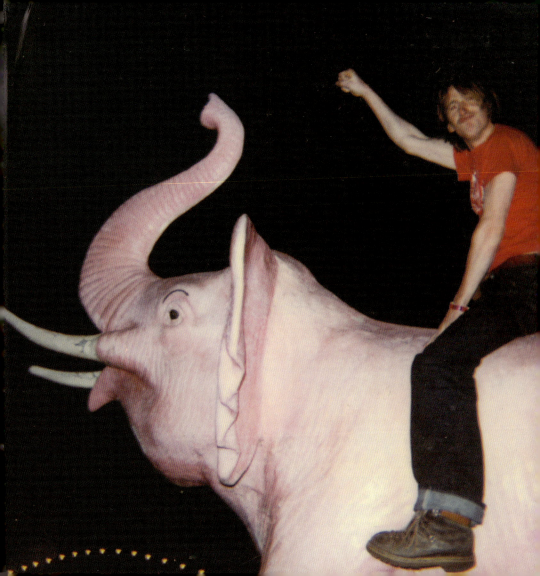

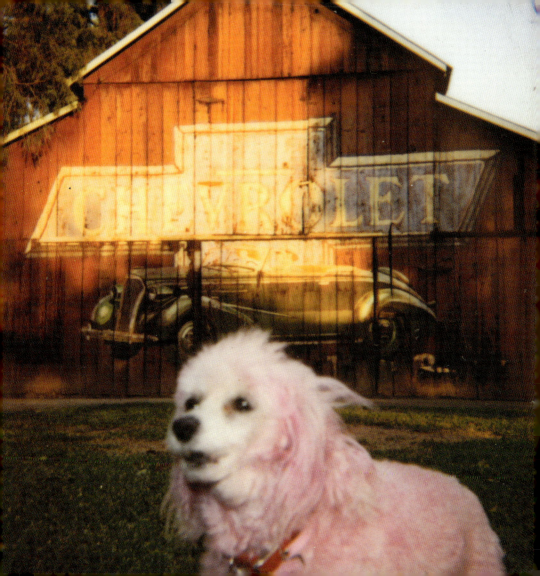

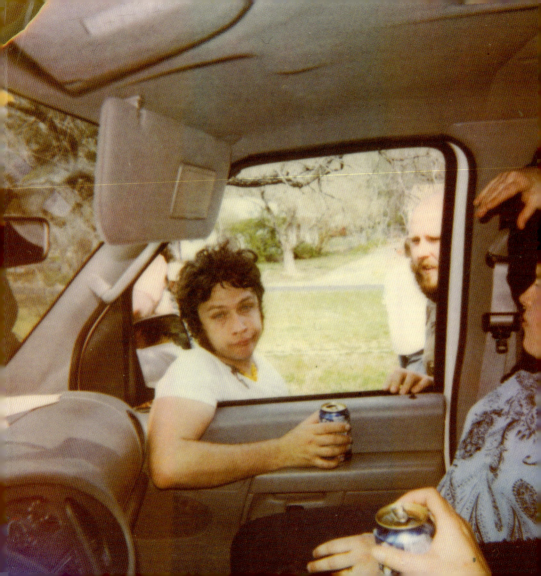

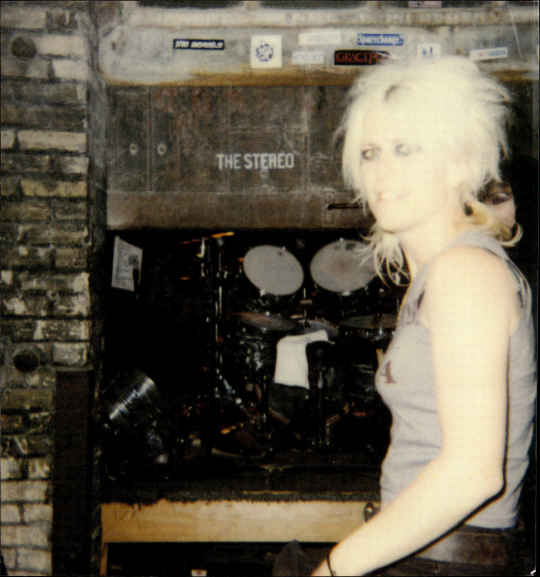

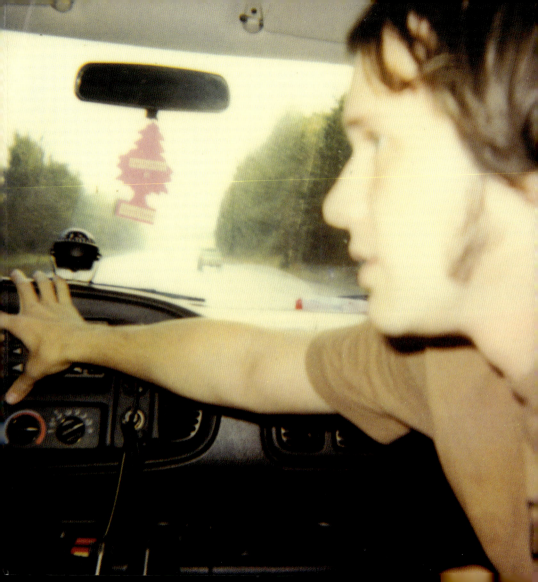

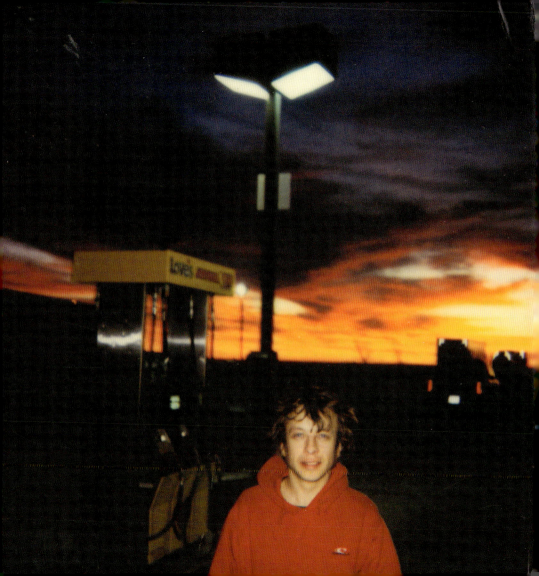

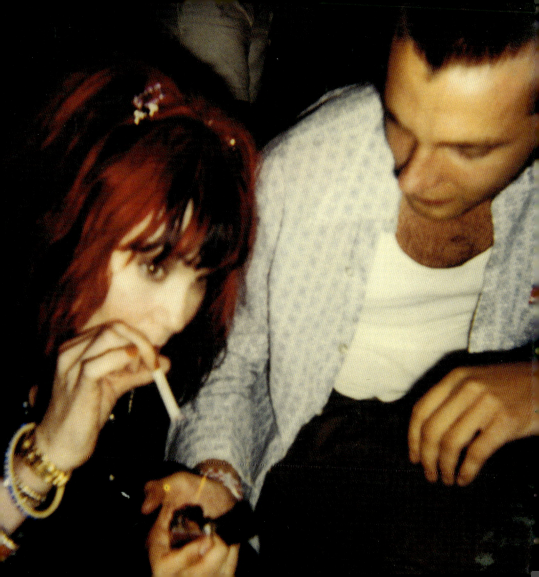

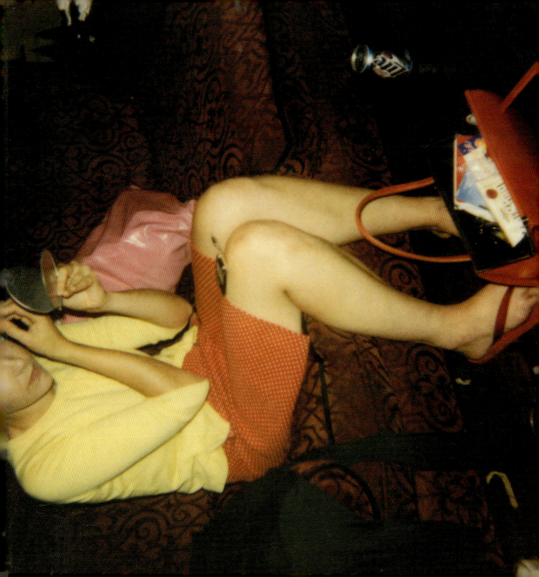

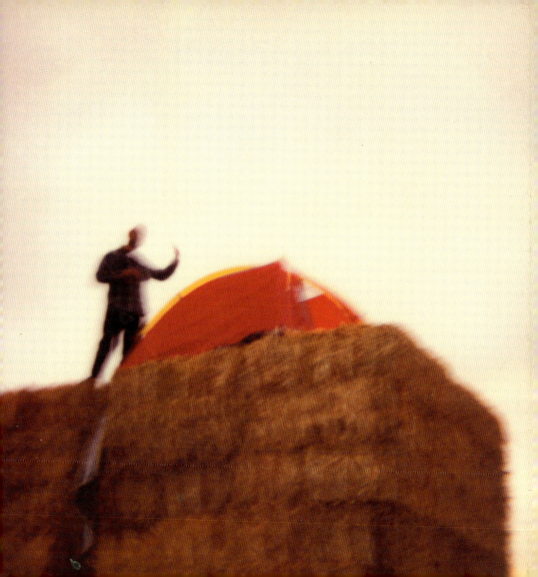

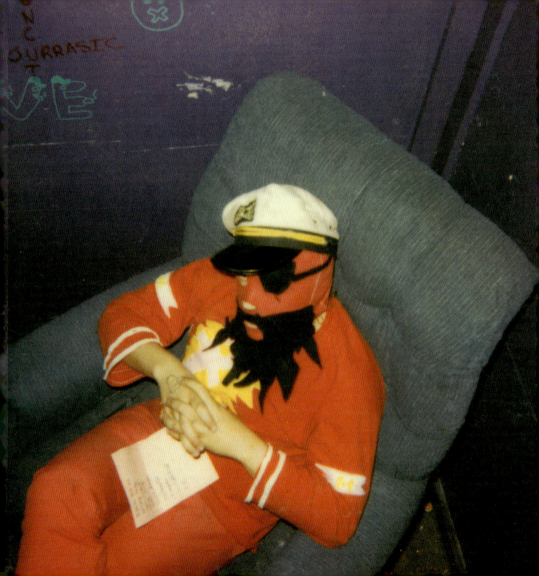

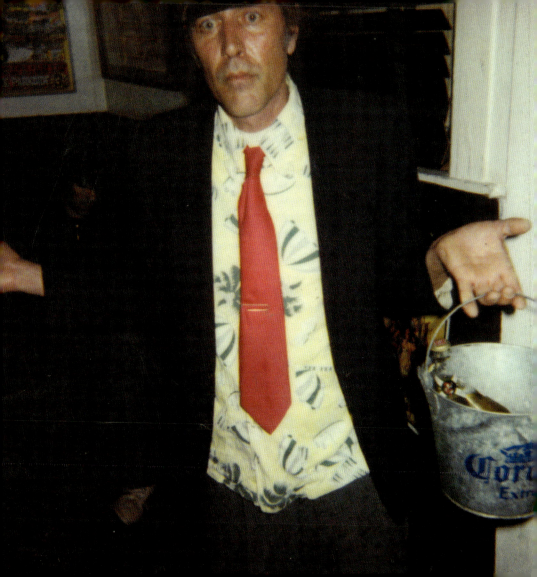

CONGRESS

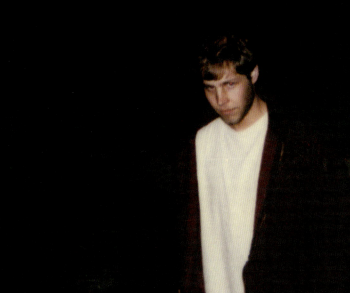

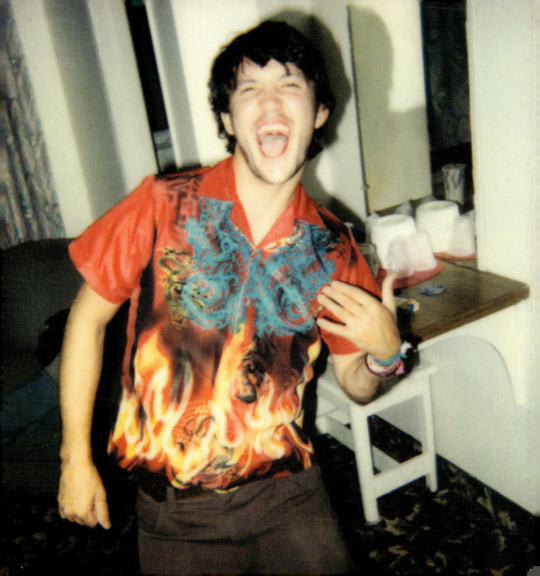

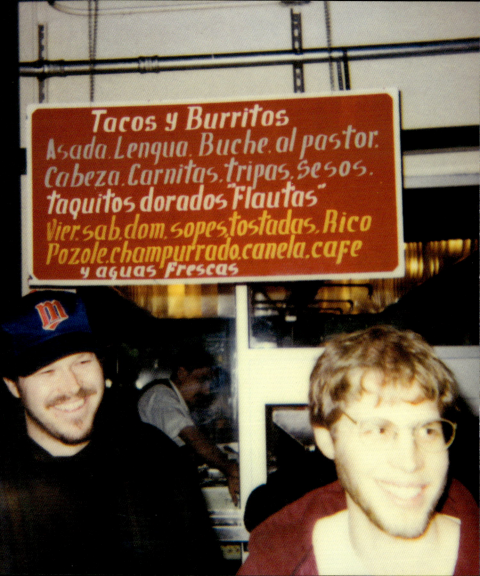

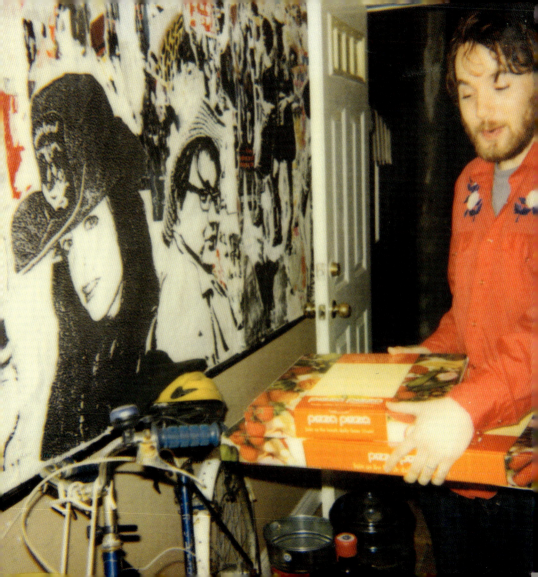

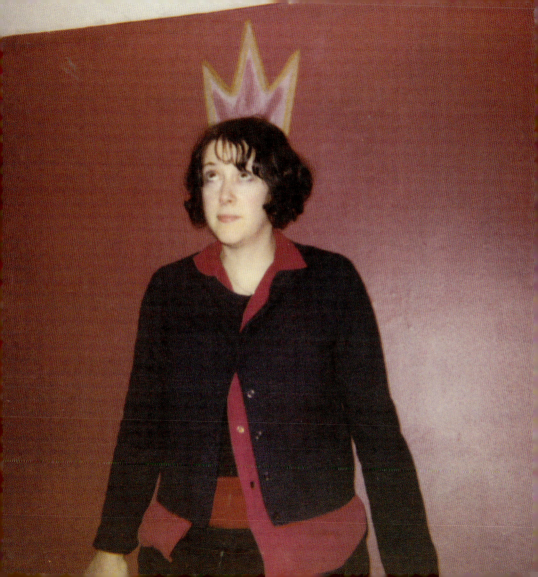

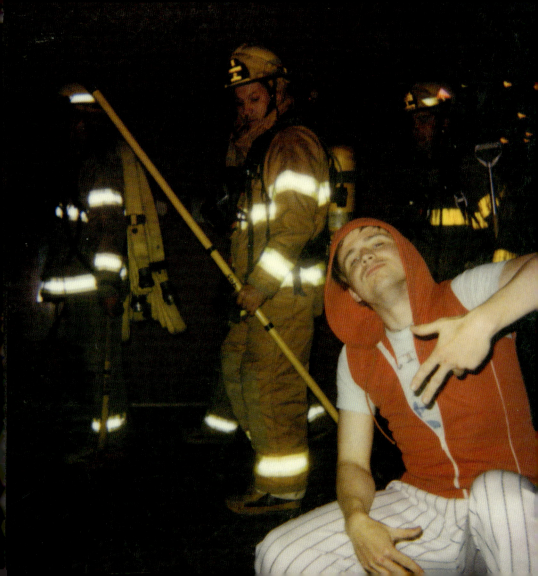

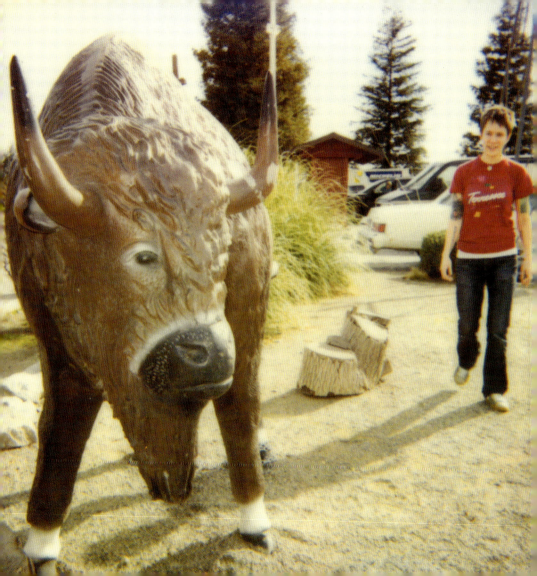

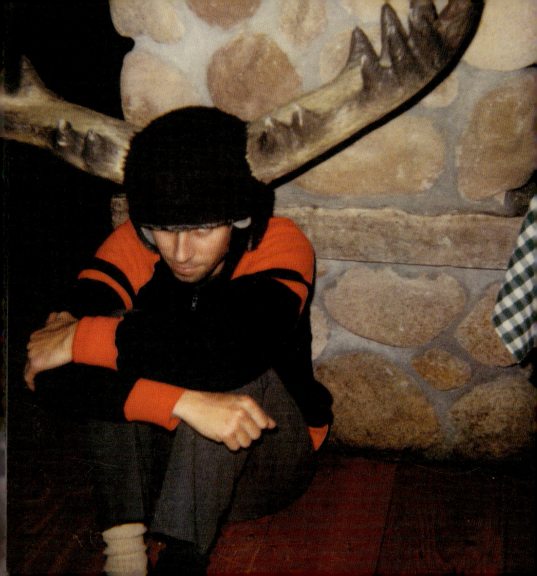

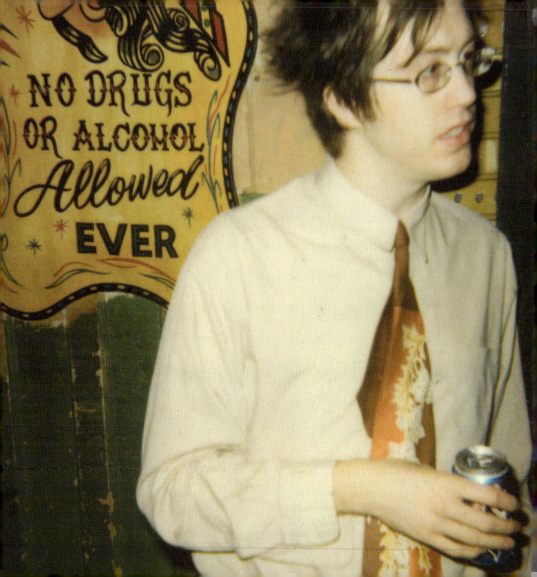

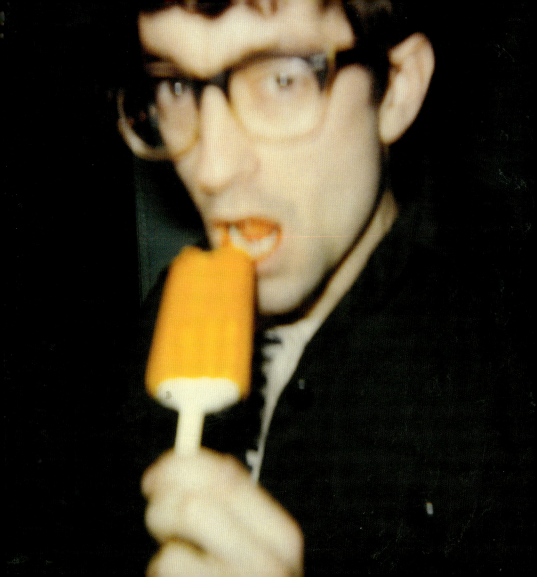

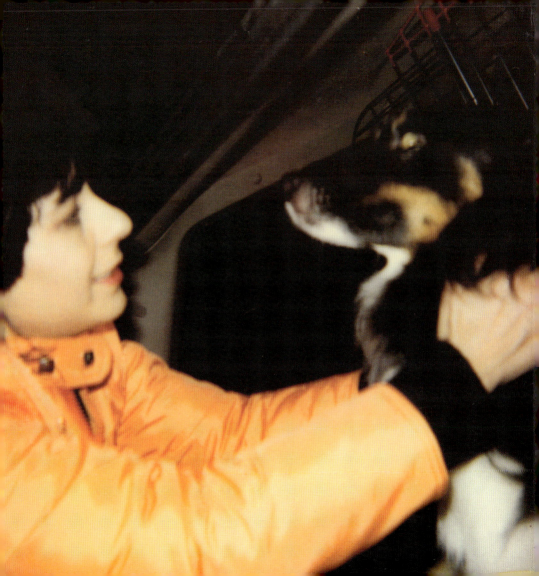

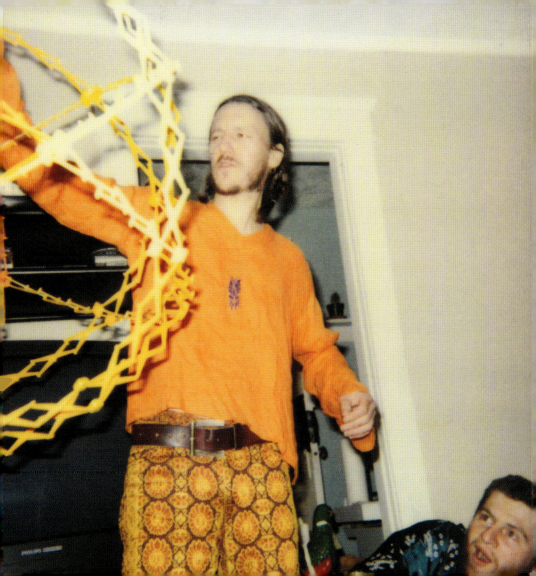

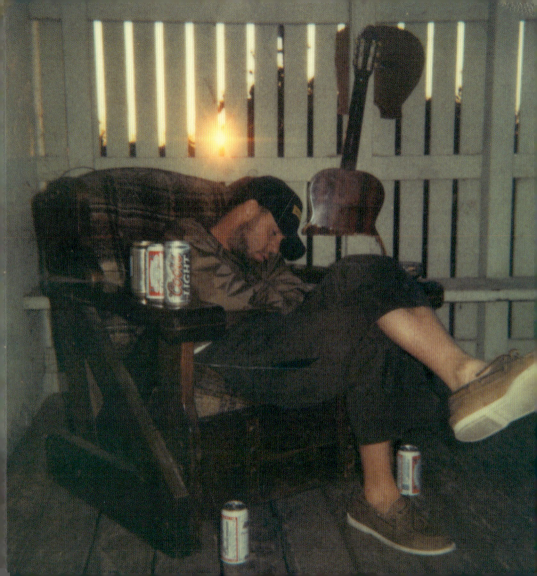

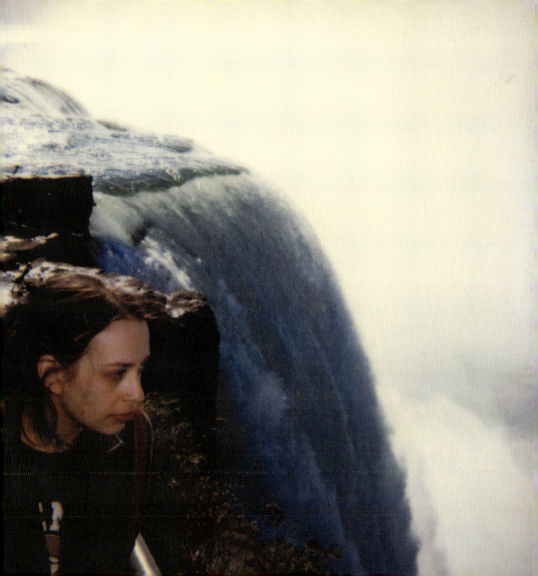

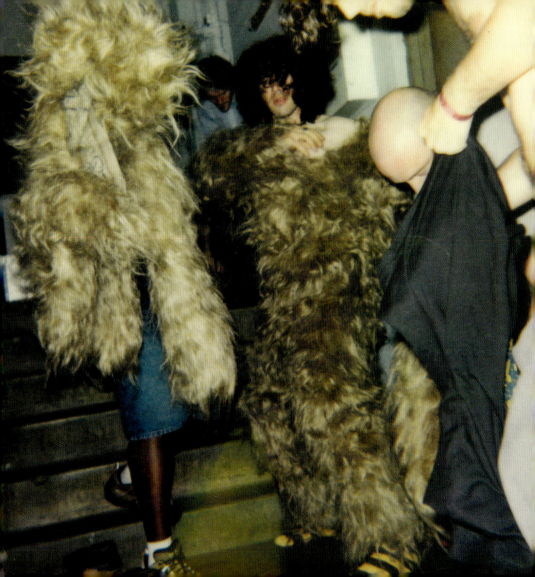

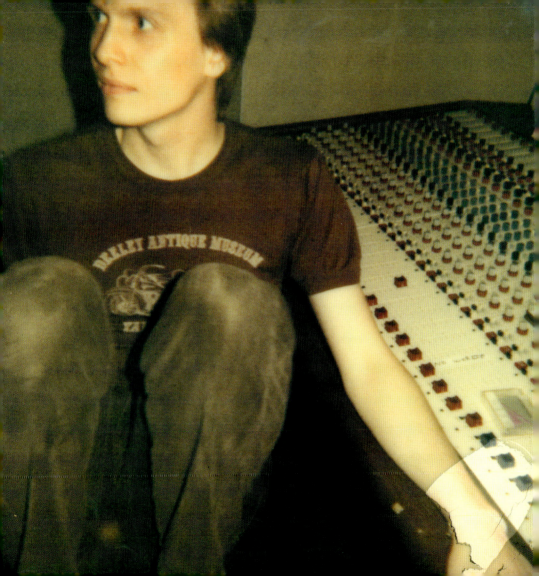

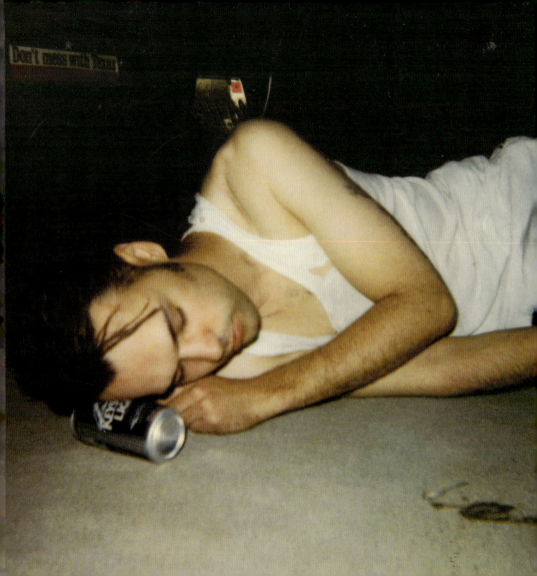

When I was playing with Preston School of Industry, we flew out of Chicago for a European tour.

← JOHN

My first big, ridiculous, behind-the-scenes experience was at a street festival in San Diego.

Exene from X invited me and my then bandmate Aaron (from Earlimart) to see them play, which they didn't do too often in those days. I was especially excited, as they were opening for Los Lobos, a band that my old Fresno friends and I had obsessed over for years. The backstage area was packed with motor homes, and each of the motor homes was packed with beer. Most of the older crowd was on the wagon, so Aaron and I quickly made friends with some Los Lobos offspring and made sure the beer didn't go to waste.

When Los Lobos finished their scorching set, they walked offstage and were greeted by a mariachi band that someone had pulled in from off the street. When the mariachi band broke into "La Bamba," it seemed almost insulting, but Cesar stepped up, belted the vocals, and everyone began to dance. It was magical. Several standards followed, and the party went on into the night—long after the police had swept all the people off the streets.

CESAR LOS LOBOS SAN DIEGO, CA →

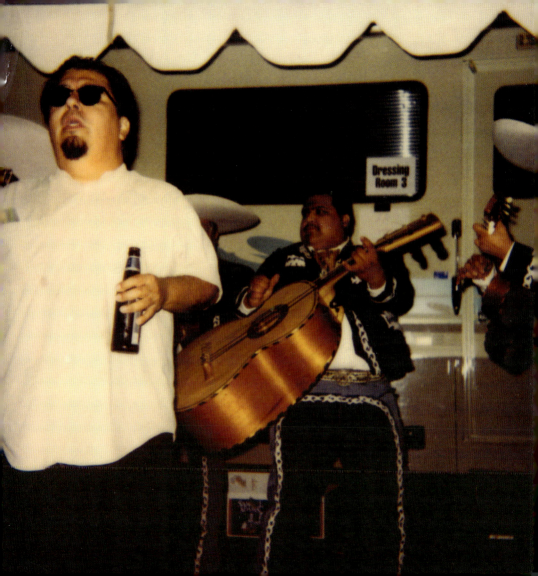

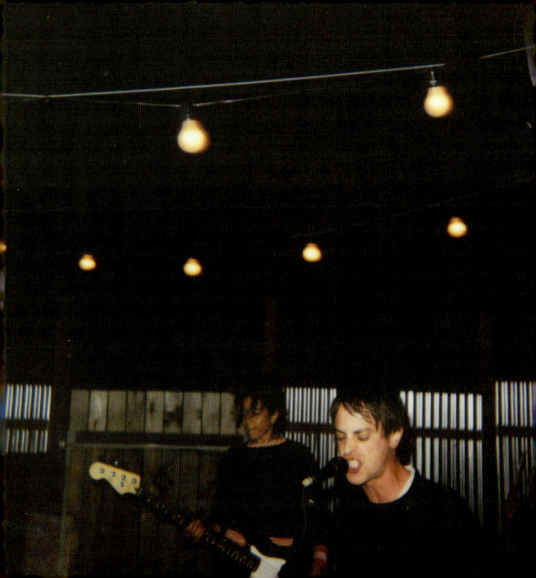

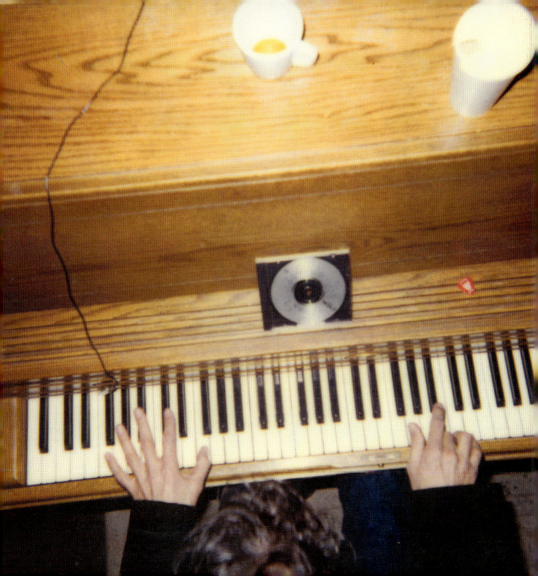

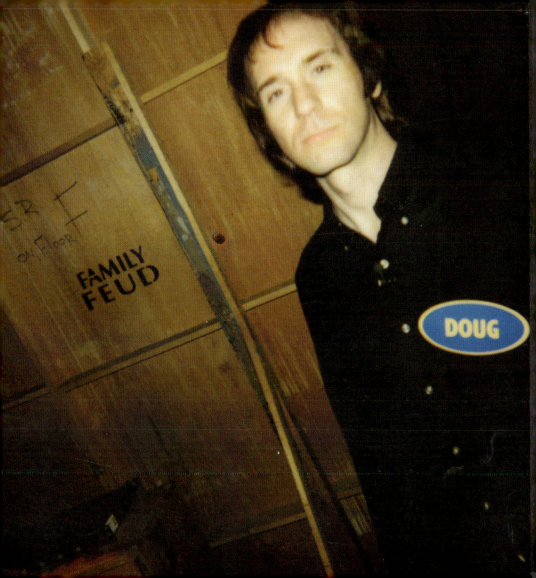

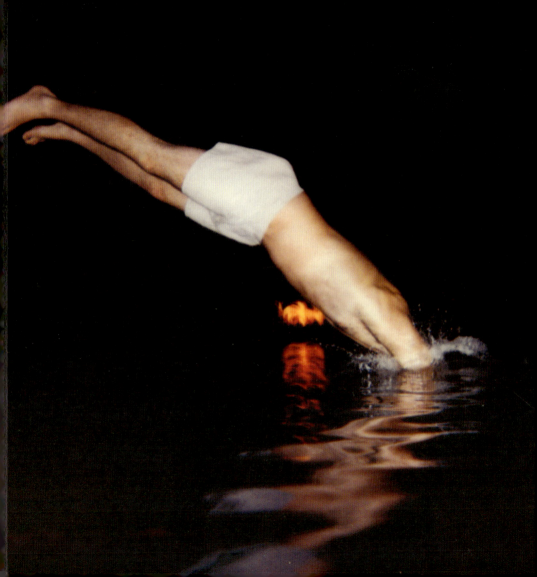

Fitchburg, Massachusetts: To be honest, I'm not sure how we met this guy.

← STEVEN

Impromptu circus peanuts missing out west on the "Golden Shoulders" tour in 2001,

Karl Blau was dressed as Gorgok and singing in a character voice. Phil Elverum and I wrote things on ourselves and performed (maybe we both wore wigs?); it was a guerilla-style attack show that was enjoyed by some. (Could it be that only our friends enjoyed it?)

Open mic ensued, so we entered. I did a walking handstand, spilling change out of my pockets, while Phil and Karl sang some made-up opera—our accidental, sober version of an acid-test type performance.

It was the most fun, most thrilling, and most unpredictable tour that I have ever been on.

↑ KYLE LITTLE WINGS SILVER LAKE, CA →

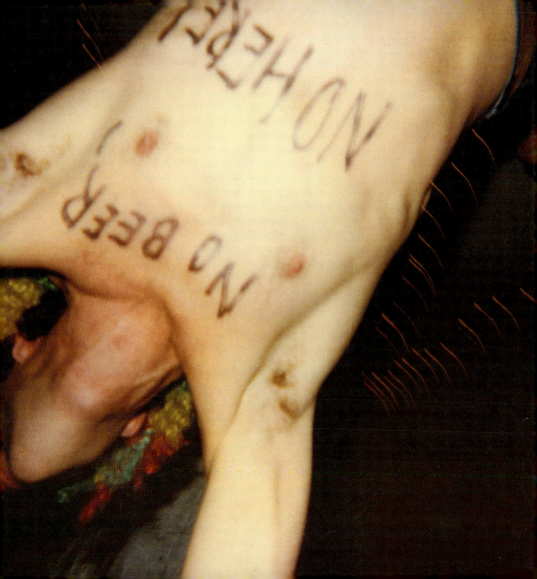

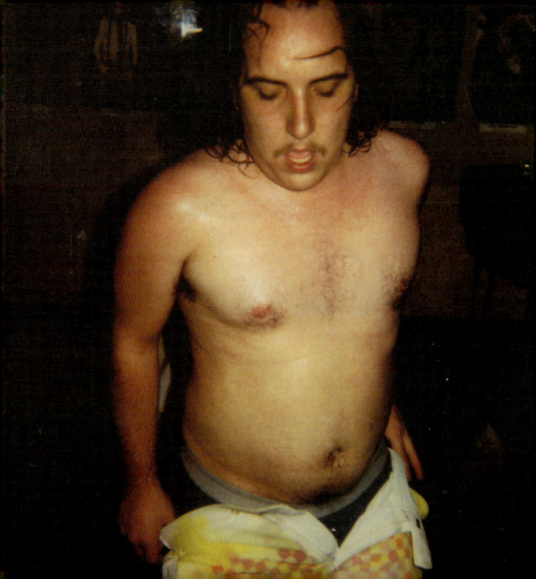

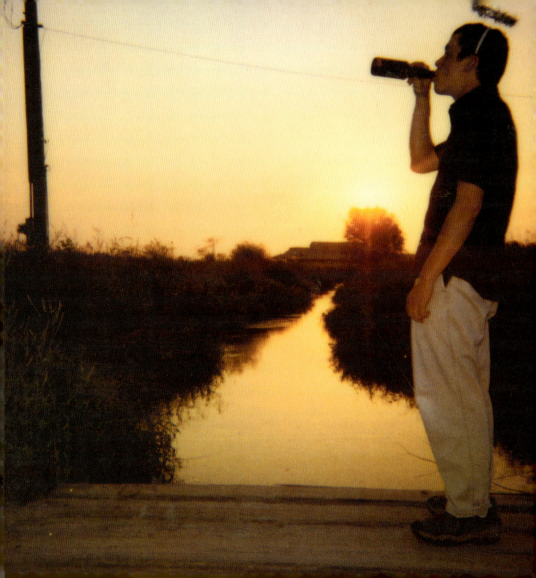

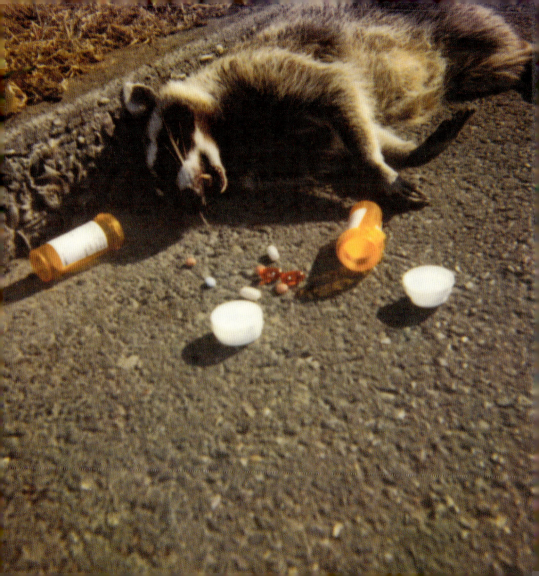

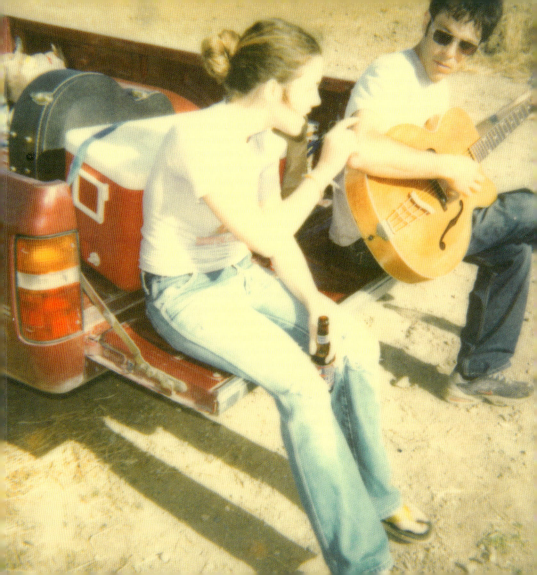

Charlie Campbell
tells the story
of this weekend
best on the liner
notes to his
Gold card record.

← JIM + SUSANE

Sometime during our 10 days together in Europe, Phil Ek, soundman for The Shins, said, "Who leaves this stuff around for Marty to find?"

It was funny because it was true. It seemed as though someone was always a few hours ahead of us, leaving props for Marty to work into his routine. Marty is, hands down, one of the most always-fun-always people, and the type of guy who brings out the best in everyone around him.

 This picture was taken just after he had obliterated a banana, a schnitzel, and Lord knows what else on our rider—Gallagher-style. Of course, my camera was nowhere near. The dilemma then was: Do I run and grab it and risk missing the fun, or f— all and enjoy the moment? I opted for the former, as I've learned that my memory is overflowing, and without documentation I quickly forget. Luckily, when I returned, Marty was still reeling and had taken his "prop," a primitive sledgehammer, to the top of a glass cabinet like some crazed ape. I had just met him and totally believed he was going to demolish the thing, but as it turns out, Marty is real sweet. Usually.

MARTY THE SHINS COLOGNE, GERMANY →

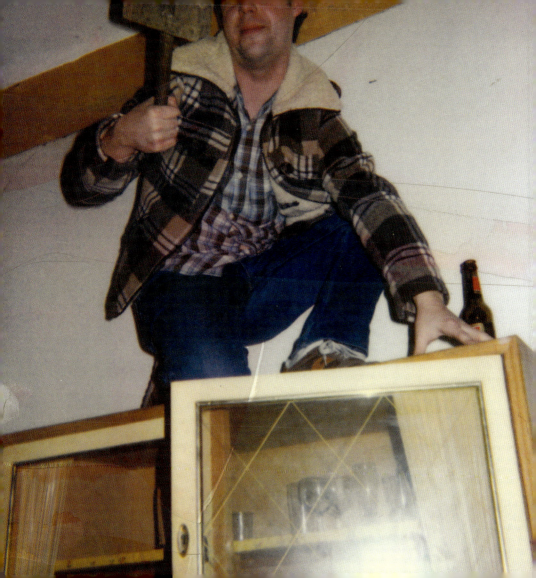

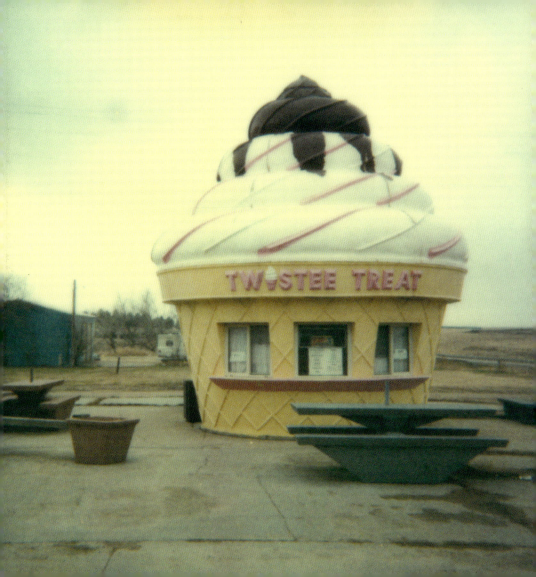

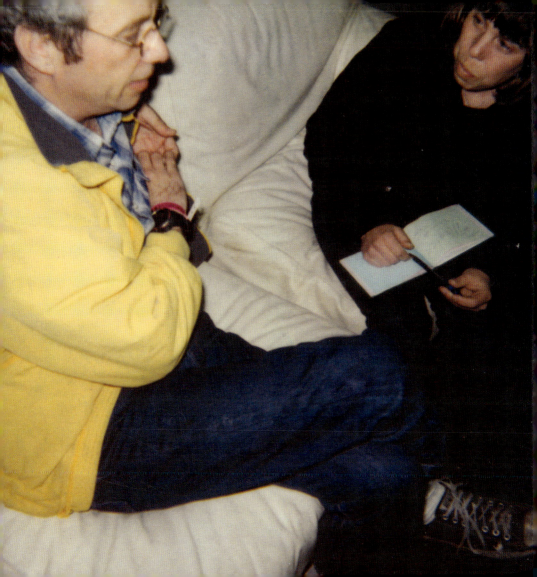

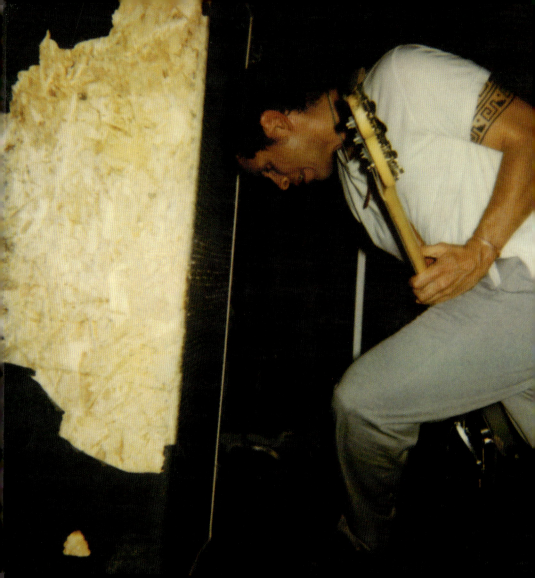

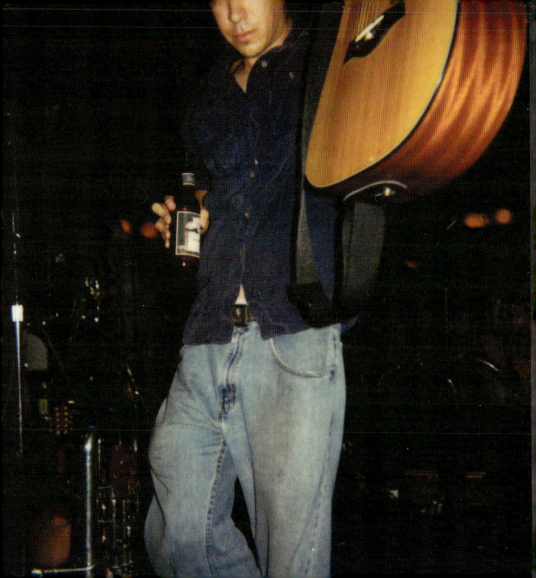

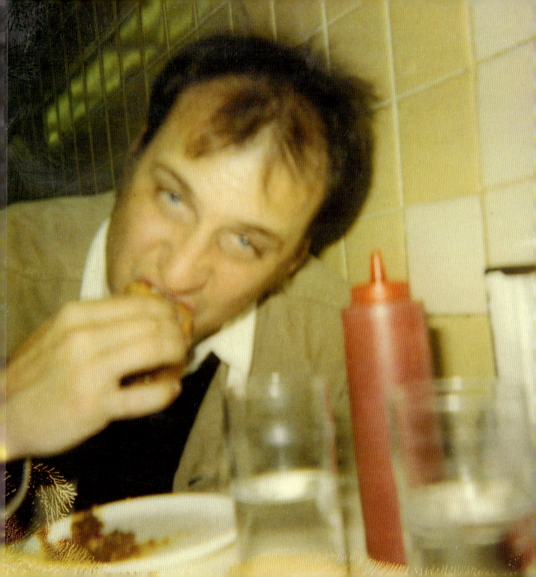

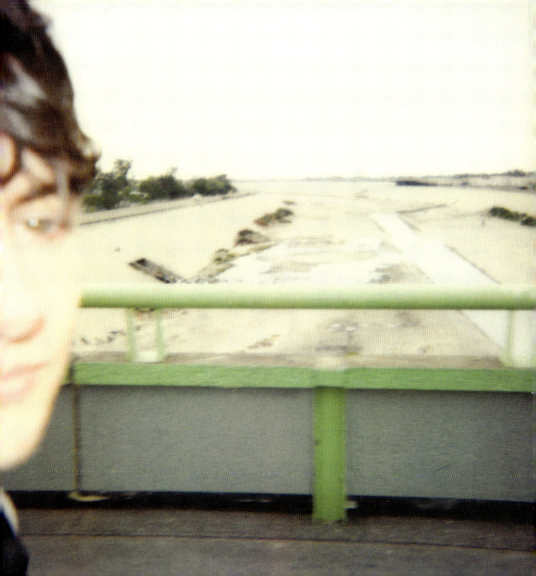

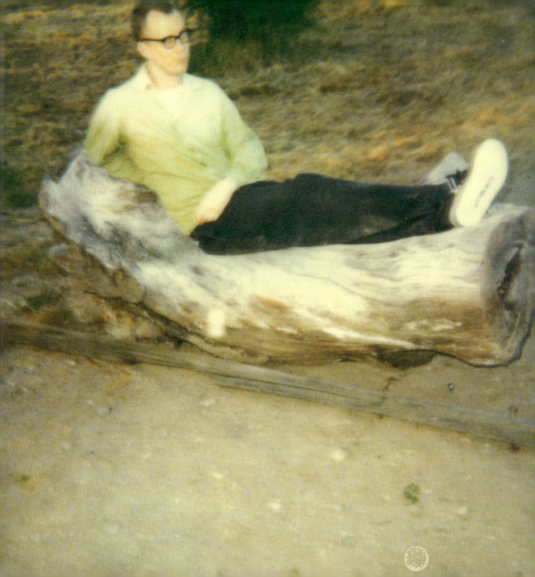

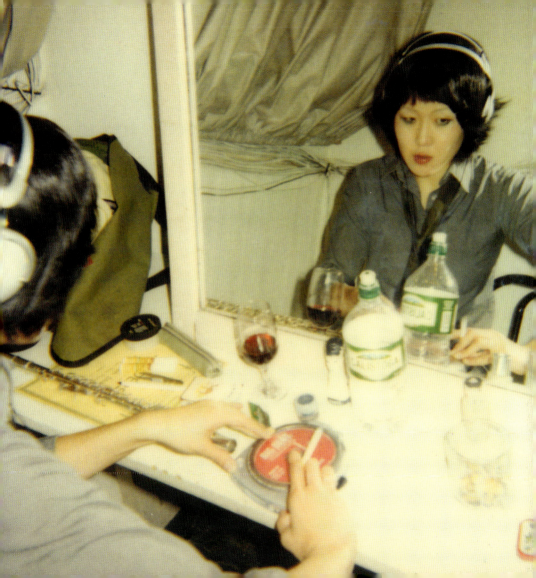

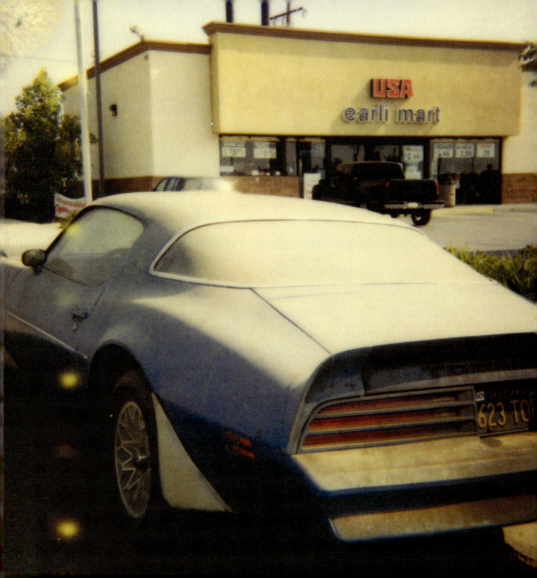

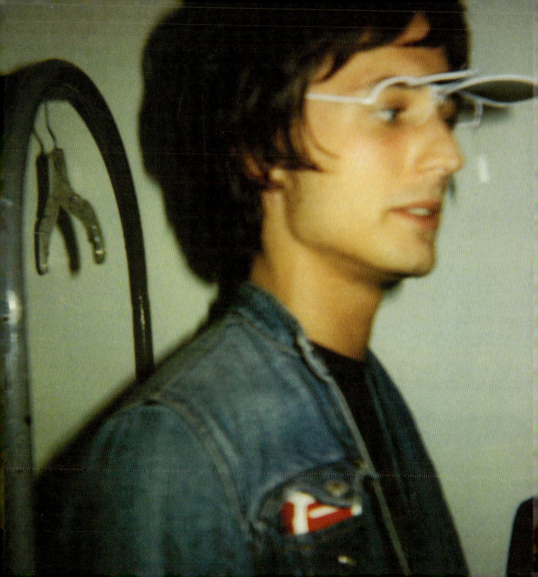

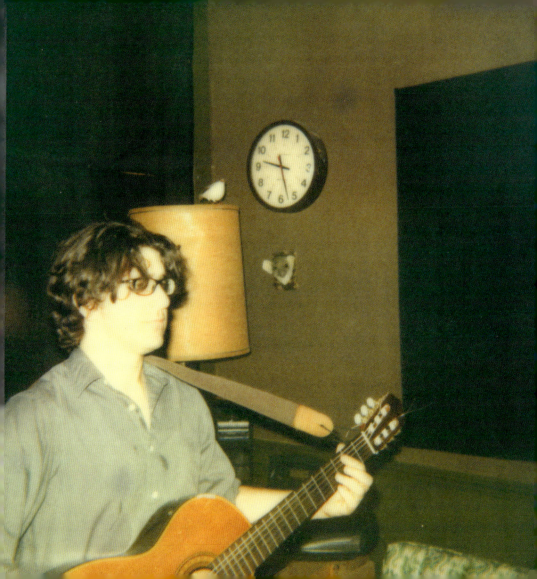

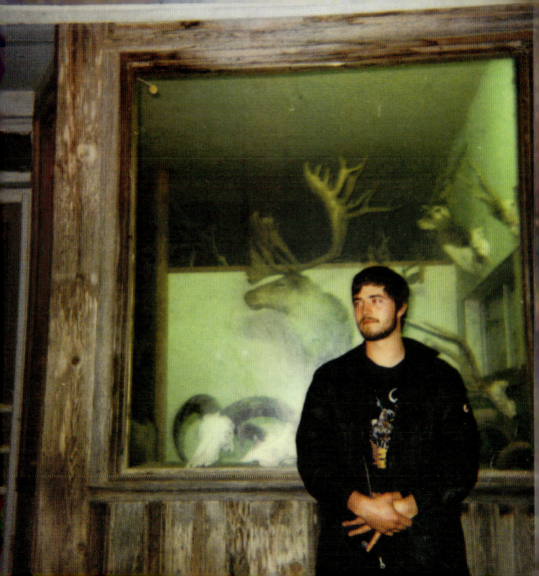

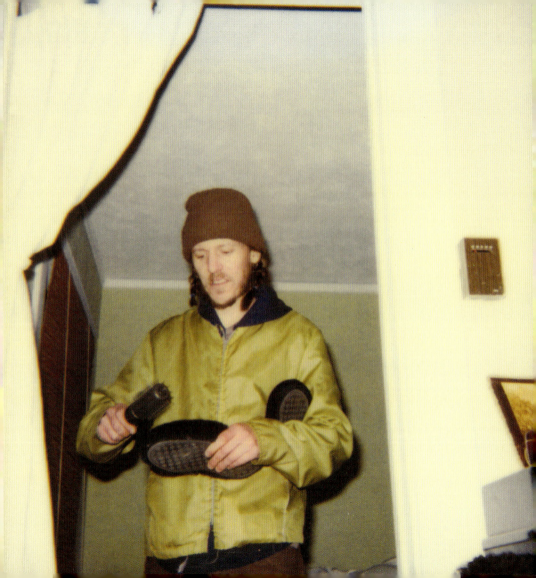

Many nights
dwindled away
at Elliott's place
since he lived
within stumbling
distance of the
bar.

← ELLIOTT SMITH

The Kentucky Derby is one of the most insane weeks of the year in Louisville

There are parades and hat contests; there's the chow wagon (tons of vendors with really weird southern food); bands play; and they have fireworks on the river. When we moved out to Los Angeles, we knew we were going to miss the Derby, and all the Derby parties surrounding it, so we decided to throw a party of our own. We let everyone in on the rules of Derby, which are: If you can, a hat is good to wear. Girls in sundresses. Boys in suits or vests. Bring some whiskey, some bourbon (preferably Kentucky bourbon), and a southern dish of your choice.

We realized, year after year, that people in California were even more enthusiastic about the Derby and its traditional aspects than were people in Kentucky because they don't have anything like it. Every year people would go all out and make fabulous dishes and get dressed up in big, fat hats, drink whiskey all day long, and have mint juleps (which we always make with home-made syrup). It's really just an excuse to hang out and eat great food and drink all day with your friends.

↑ CHANDRA + JASON THE WATSON TWINS BURBANK, CA →

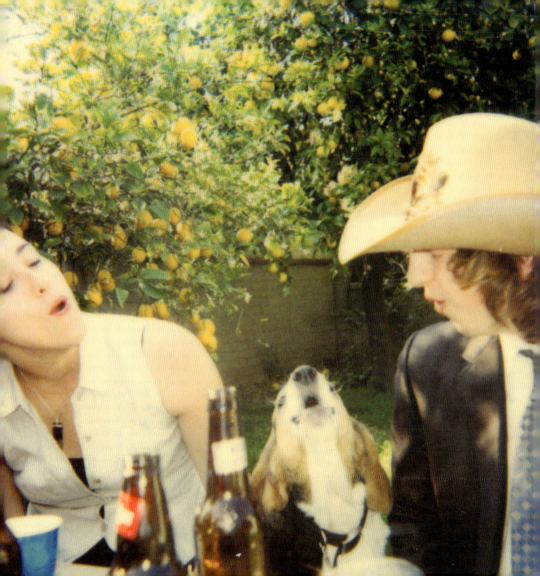

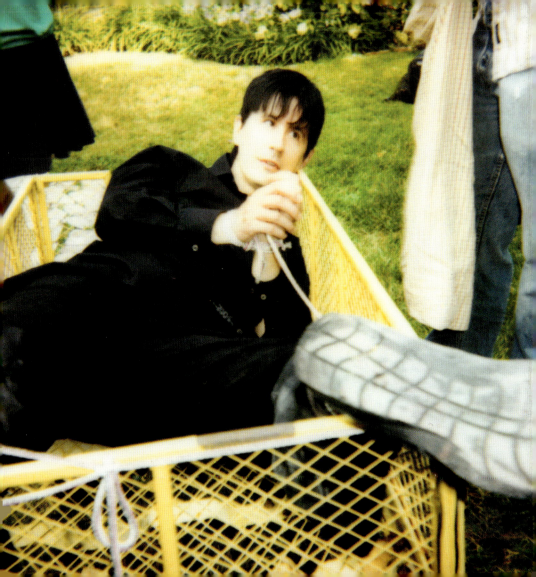

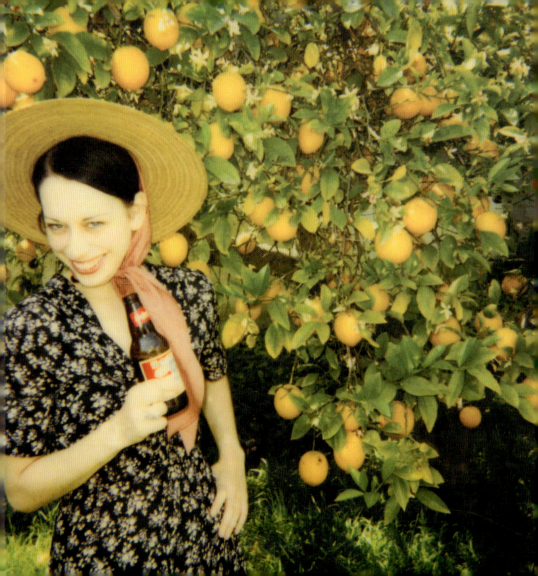

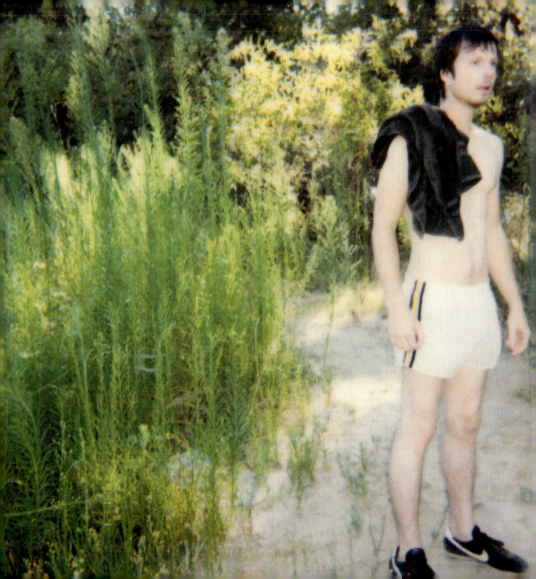

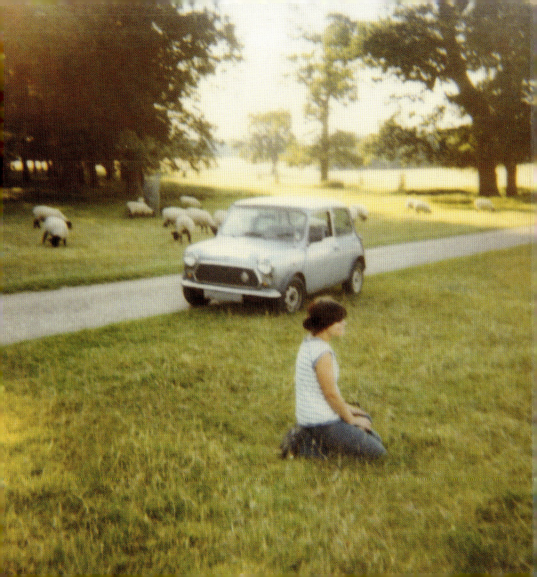

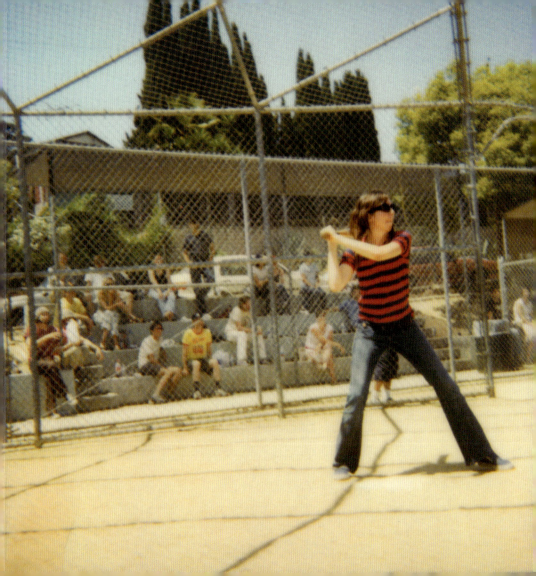

July 4th
is one of my
favorite holidays
of the year.

← NIKKI

Most musicians live and die by breakfast.

Due to the hectic schedule of touring, breakfast-time is often the only time you have to explore a city while it's still light out. It's a time to catch up with friends without the stress of having to play a show—or the craziness of having just played a show. It's a time to sop up whatever queasiness may remain in your belly from the night before and start anew.

This is El Vez in his nineteen-fifty-something hot-aqua Chevy, chauffeuring some hung-over folks deep into East Los Angeles for deliciously lardy Mexican food. I'd lived in Los Angeles for several years and had never heard of the place, but after this day it became the go-to for many of the bands who slept on my floor. Apparently, it goes by a few different names—the most common being El Mercado de Los Angeles—and it is three floors of loco: a marathon for the senses.

Upon pulling into the parking lot, you are bombarded with so many colors, smells, and sounds that it's almost paralyzing.

My advice is to push through and find your way to the top without becoming too distracted. There, you will likely be bulldozed by the cacophonous sound of three separate mariachi bands blaring away in three separate theme rooms. Choose your favorite (I prefer the fishing village), take a seat, and start in on the *cerveza*. Not one of the employees speaks English, so stick to the menu items that look familiar or you may end up with a bowl of cow intestines. Then sit back, enjoy the *música fantástica*, and once you're appropriately full and buzzing, sprint off and explore the rest of the place. The person who ends up back at the van with the weirdest souvenir wins.

EL VEZ ATWATER, CA →

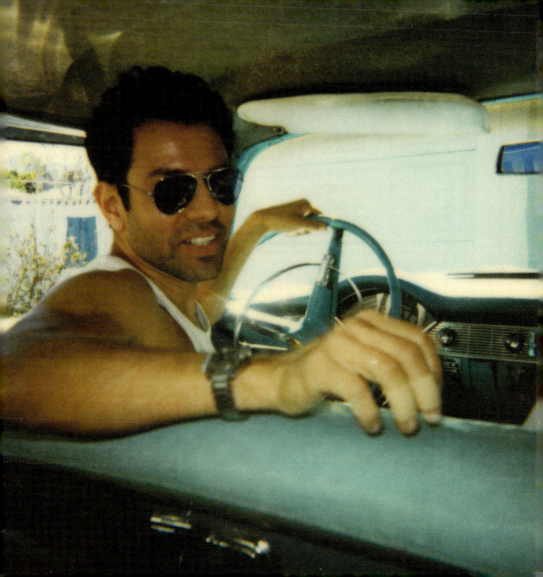

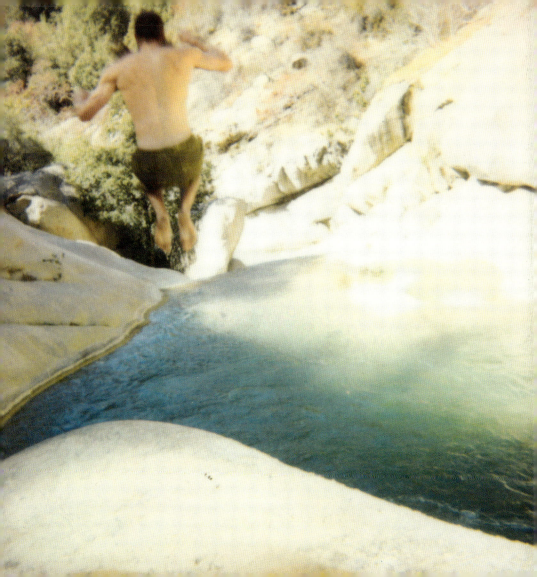

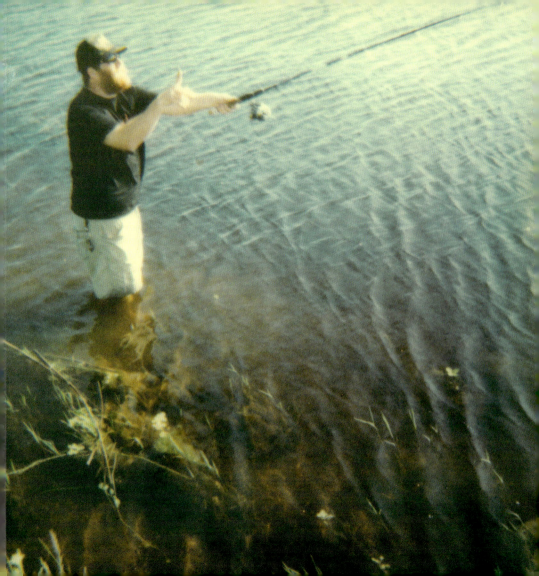

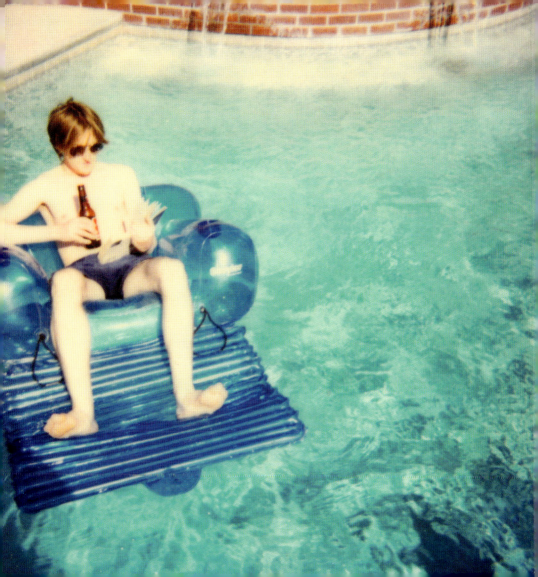

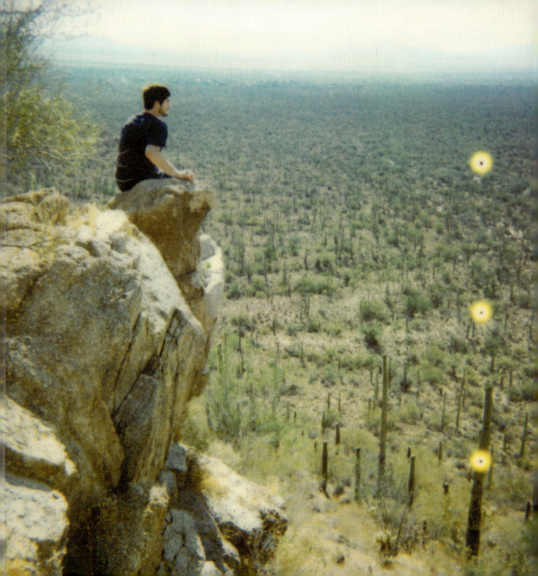

This typical
road-weary morning
began when I woke
up on the floor of the
tour van, roasted to
about medium-rare

← MARK

This photo was taken on Okkervil River's brief tour as an opener for Rilo Kiley, in June 2005.

A bunch of folks chipped in, and over the years the little studio we built outgrew my bedroom and moved into a storefront in Eagle Rock. We called it The Ship.

We were the second residents on a block that now features several recording studios, practice spaces, and artists' lofts. It was a very communal atmosphere, and a place where everything from mics to musicians to alcohol to advice was shared.

I took this picture when Will was over, lending his vocals to a Kaito song. While noodling on a guitar during a moment of downtime, he came up with a part he didn't want to forget and stepped outside to leave it on his home answering machine. I always feel bad about intruding on intimate moments with my noisy camera, but I know that what I'm doing is recording them so I won't forget.

WILL HEY WILLPOWER + IMPERIAL TEEN EAGLE ROCK, CA →

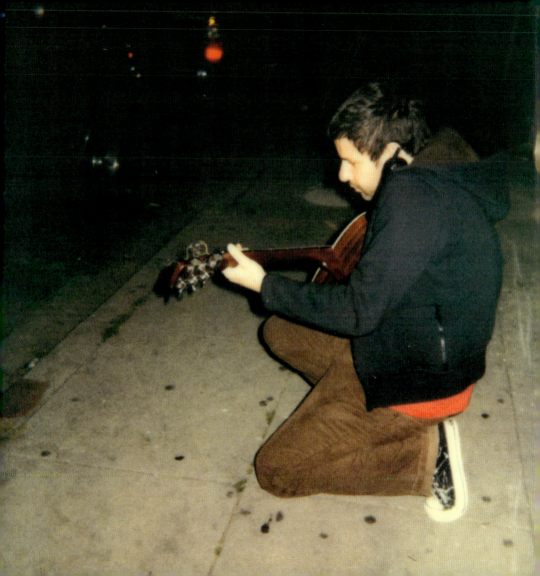

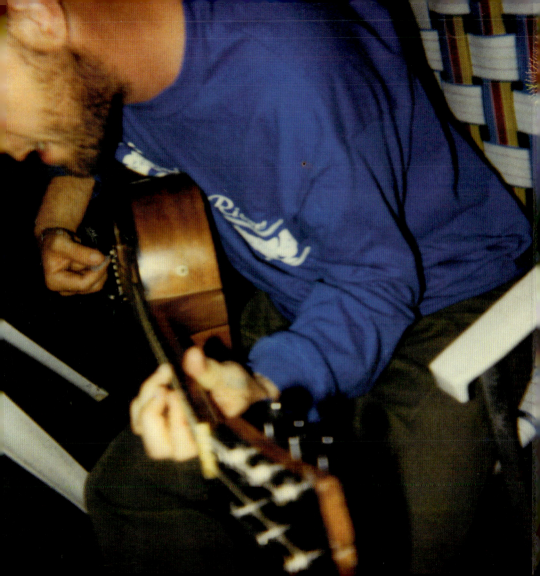

When the monotony and boredom of a tour kick in, you can always count on some strange something, somewhere, to pull you out of it.

← TIM

Late one afternoon during a day off in San Francisco, we got a call from some friends in Modesto.

They were having a party and wanted us to come. It made no sense to go, since we'd have to turn around and drive back to San Francisco the next day, but friends always win over sense. As it turned out, the Death Cab fellows also had the day off, and they'd decided to make Modesto their home for the night as well. They brought with them big smiles, forties of Country Club, and Sunny Delight. The party soon moved into the dank garage (because you could spit in there, and everyone was in a spitting mood) and the acoustic guitars followed. Ben and Chris whipped through every Guided by Voices song they knew, and though Death Cab for Cutie was not yet a household name, it was obvious we were witnessing something special.

BEN + CHRIS DEATH CAB FOR CUTIE MODESTO, CA →

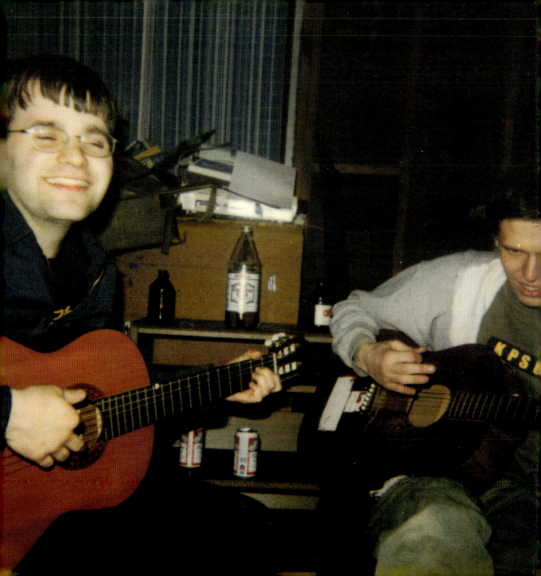

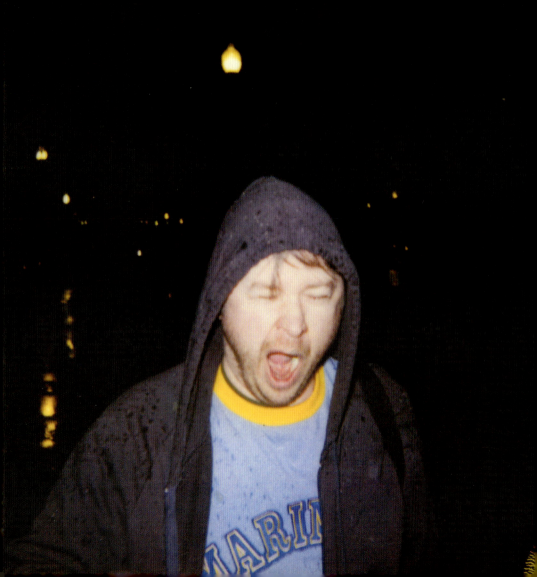

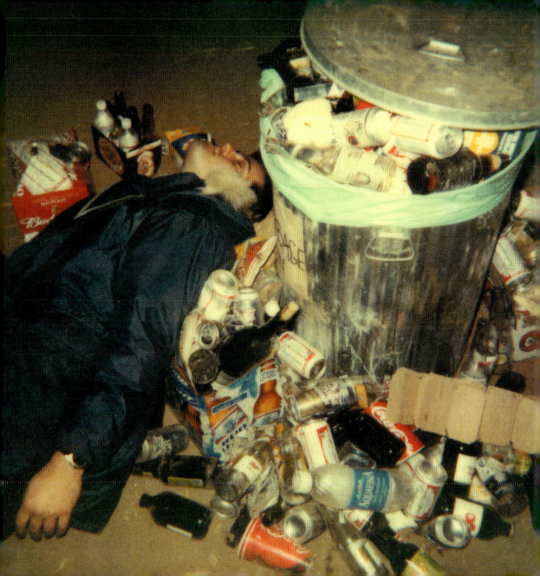

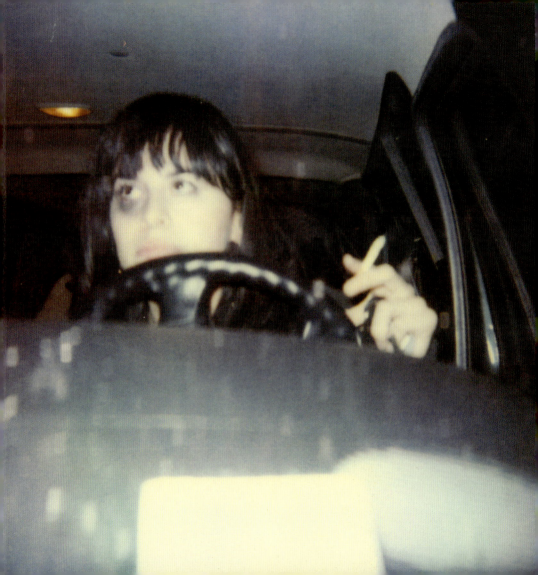

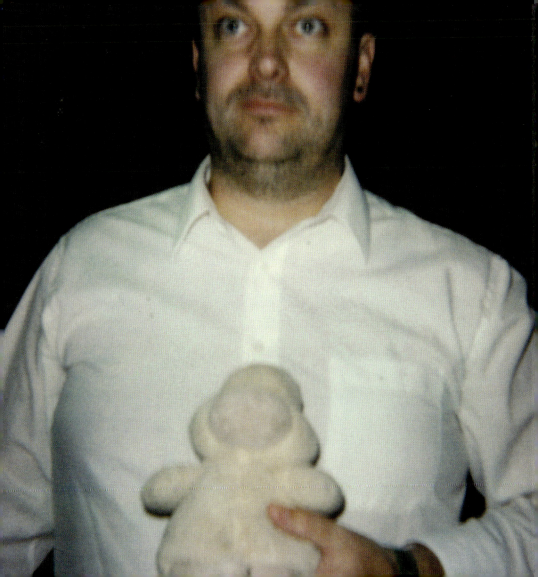

Early in the Trail of Dead's career, we had the opportunity to open for them— in a warehouse in downtown Los Angeles.

← NEIL

It is such an unusual and sometimes venerable place to be out on the open road.

The best part about it is bonding with the folks you're traveling with. At the time this photo was taken, there was unadulterated, wacky, silly freak-out bondage between The Swords Project and Irving at a weirdo, fantastical truck stop in South Carolina. While I was shooting the silliness of our tribe with my Bolex, Ashod snapped this one of me, obscured by a spring-loaded jackalope. It sums up the vibe perfectly.

↑ JEFF THE SWORDS PROJECT SOUTH CAROLINA →

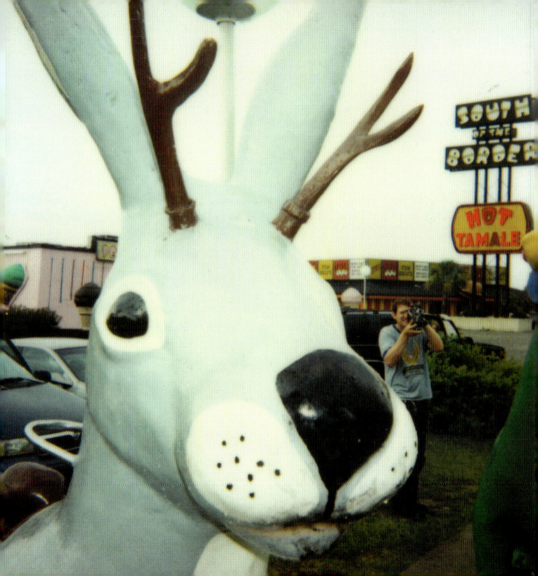

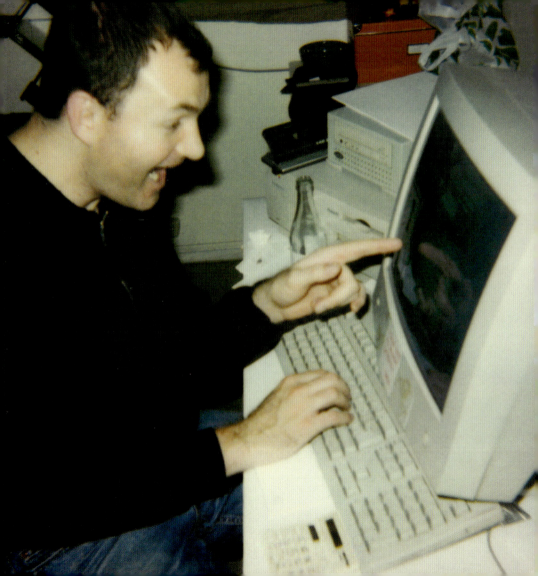

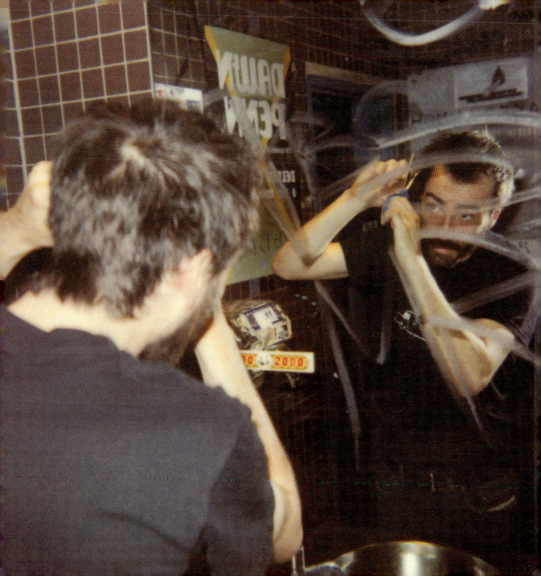

The setting for this was one of those big, silly rock festivals in the middle of nowhere.

← CHAN

I was taking a nap on a friend's couch and I awoke to someone sitting on me.

It was Daniel. He offered me some of his Sno-Cone. Later, he hugged our bass player for a little longer than what is generally considered normal. Much later, my band Panty Lions had the opportunity to open several shows for him over the course of a three-week tour. I relished the thought of documenting that period, knowing that I would witness some truly amazing stuff.

 Sadly, three days into the tour, Daniel disappeared. His tour manager said it was food poisoning, that he had flown back to Texas.

The night before, we had played at a venue in San Diego that was attached to a Mexican restaurant and Daniel said to me, "You know you've made it when you get to play the taco shop."

 I didn't get to know Daniel very well, but being around him, and seeing how his fans treat him, one gets the feeling that he identifies more with The Beatles than with the outsider artist that he actually is. The Beatles would never play a taco shop.

DANIEL JOHNSTON NEW YORK, NY →

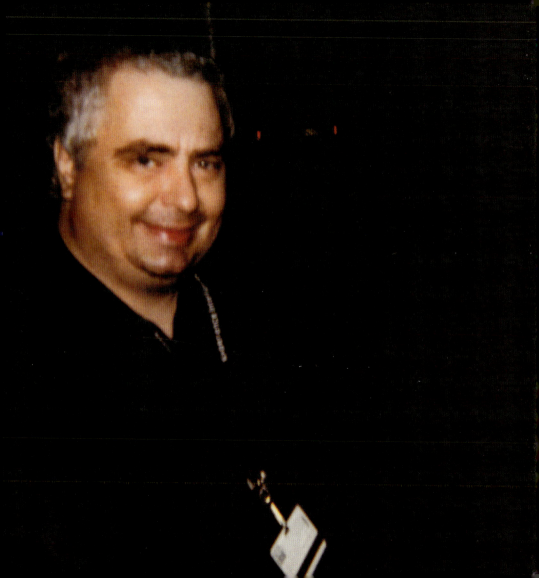

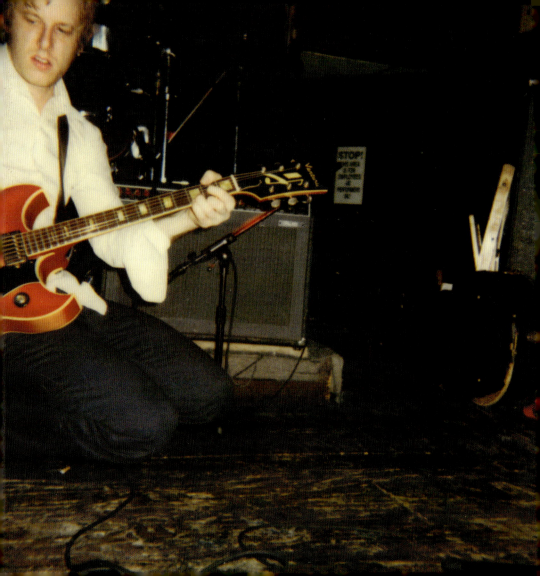

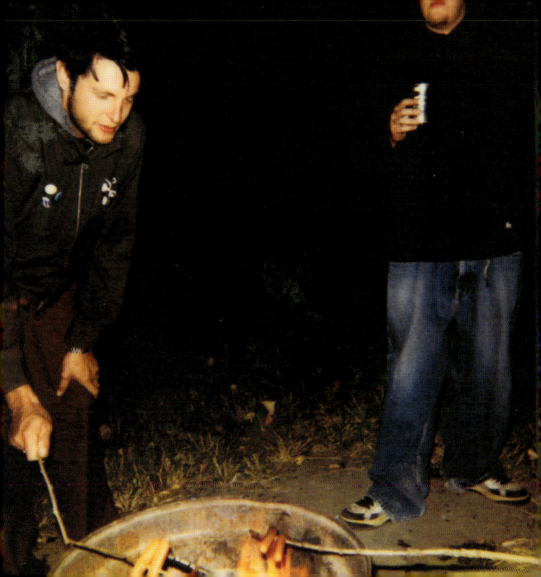

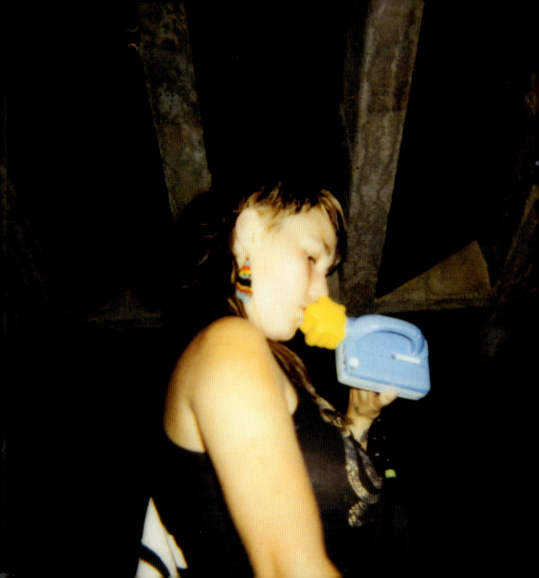

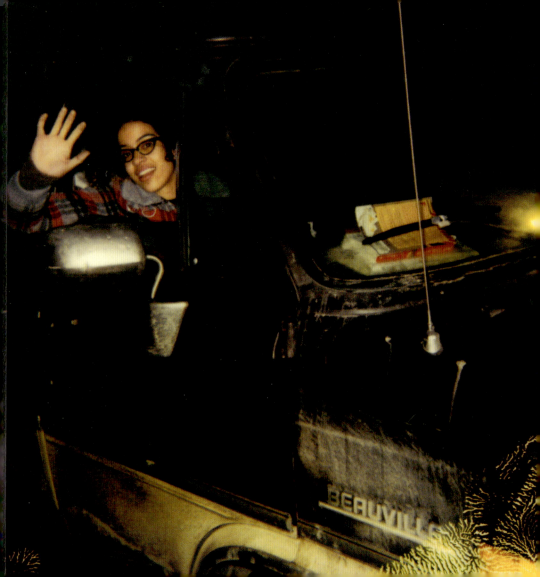

There's nothing like driving through a snow storm on tour...

← KATHY

Author's Note

Recently, it has come to my attention that all my dreams have come true. It's a feat that I'm fortunate to have achieved.

This book is filled with moments I've captured of others realizing their dreams as well. Most of them are friends, or friends of friends, who I have encountered along the way, as we were all traversing the same trails to reach our goals. Incomparable camaraderie and experiences so unique that they couldn't be scripted created indescribable kinships. Anybody who has been on tour, playing music for strangers, even for a short amount of time, can attest to the fact that the lifestyle is intoxicating.

Unlike most of the subjects included in this book, I don't have "fast" fingers or "good" ears. I can't "hit" notes or "keep time," necessarily, but I know how to have fun and sometimes that's just as important. I love music and surround myself with as much of it as possible, and so without thinking too much about it, I began documenting the people who were making it around me.

I started shooting with a Polaroid 600 (also known as the One-Step) around 1996. One night I made the forty-five-minute drive from my hometown of Fresno, California, to a dive bar on the outskirts of Visalia, a small farming community, to take pictures of a friend's band. I hadn't yet graduated from the feedback experiments conducted alone in my bedroom, so my only connection to the local music scene was as a fan and a photographer. Unfortunately, that night I forgot my camera. Rather than drive all the way back to Fresno, I decided to just buy a new one. Goodbye

35mm, hello Polaroid. (Over the years I would repeat this process, at roughly thirty-five dollars a pop, every time I lost, broke, or forgot my camera.)

It wasn't long before the photos began to take on a life of their own. Gone were the uninspiring shots of folks posing with their arms around each other. Even pictures of bands playing live became scarce. What emerged instead were candid shots of folks having fun, before and after the shows. The photos often mirrored our buzz: all blurry and bizarre. Watching them develop over three short minutes, with the blank whiteness slowly engulfed in a muddle of nostalgic colors, it felt like I was already holding a warm memory of the distant past.

In the year following the purchase of my first Polaroid, I moved into a house in the Silver Lake hills with a bunch of friends, including three members of that band from Fresno. The band dissipated over the course of the move, but several more sprung from the fertile environment of that house and that community and that era of our lives. Our home became an epicenter for several creative projects, which we released under the moniker The Ship, and also served as an all-night watering hole for friends in the neighborhood, as well as an inn for bands passing through. I somehow found the confidence to begin writing my own quiet little songs using the name Panty Lions, but it was another band I contributed to, Earlimart, that first garnered a modicum of attention. We piled into my van with empty pockets and big dreams and watched, dumbfounded, as the next several

years sped by in a blur of hangovers and highways. We opened for some of our favorite bands, saw our pictures in some of our favorite publications, made some wonderful friends—and though we were hardly "successful"—we felt very much on top of the world.

That all changed on August 25th, 2001, when a plane carrying R&B singer Aaliyah went down in the Bahamas, killing everybody on board. When I first heard the news, I had no idea that one of my dearest friends and one of our biggest supporters, Doug Kratz (lovingly known as Pikul), had filled in at the last minute for his boss to oversee Aaliyah's video shoot. Our close-knit community of friends was devastated—just ruined. I felt especially fragile and was unsure what to do. Driving in the procession from the church to the cemetery, I fixated on the bright orange "FUNERAL" sticker affixed to the upper-right corner of the windshield. From my perspective, the type was reversed, and through teary eyes I had misread it as "REALFUN." I don't think it was a sign, but I adopted it as a mantra anyway: Real fun from here on out. There wasn't time for anything else.

The years since have found me on the road more often than not. For a good stretch I was officially homeless, and in between my own tours, I would manage tours for other bands, in part so I would have a place to sleep at night. My personal possessions had been whittled down to two bags, a camera, a guitar, and an amp. Anytime I got an inkling to "settle down," someone would inevitably call me up and coerce me to get back out there. For a while there, I even got to play in

one of my favorite bands, Preston School of Industry—with one of my biggest influences, Scott Kannberg, whose previous band, Pavement, shaped much of my sentiments about popular music. I was seeing the world, hanging out with folks from my record collection, and living each day as if it could be my last.

Looking back at these photographs (a tiny fraction of my collection), I am more amazed by all the moments I missed than by all the memories I captured. For each picture taken, there are hundreds of moments when I was too shy or embarrassed by the obstructive flash and obnoxious click and whir of the camera to pick it up. For each of those instances, there were a hundred more when I had left my camera behind, either accidentally or because I hadn't anticipated a reason to bring it. For each of those times, there were hundreds, maybe thousands, of other folks and other friends doing something ridonkulously entertaining somewhere totally exciting in the world without me. For these reasons, this book is by no means a definitive representation of independent music from nineteen-whatever to two-thousand-something, but rather one person's view of the landscape surrounding him at that particular moment. I hope the energy in these Polaroids might inspire you to forage, or continue foraging, for your own personal, unimaginable, incomparable real fun.

And I thank those who somehow keep helping me to find mine.

This book is dedicated to the good times we shared.

REAL FUN

POLAROIDS FROM THE
INDEPENDENT MUSIC
LANDSCAPE

ASHOD SIMONIAN

A PictureBox Book
www.pictureboxinc.com

Editor: Sasha Hirschfeld
Creative direction and design:
Jessi Rymill and Carl Williamson for Circle & Square
Illustrations: Frank Santoro
Handlettering: Norman Hathaway and Jon Vermilyea
Assemblage and production: Jon Vermilyea
Copyeditor and proofreader: Jessi Rymill
Publisher: Dan Nadel

Available through
D.A.P./Distributed Art Publishers
www.artbook.com

Real Fun is copyright 2007 Ashod Simonian.
All songs copyrights their respective creators.
All rights reserved. No part of this publication may be reproduced
without the written permission of the author or publisher.
Printed in Hong Kong through QuinnEssentials.

First Edition

www.circle-and-square.com
www.ashodsimonian.com

ISBN: 0-9713670-9-4
ISBN 13: 978-0-9713670-9-8